Love You
MOM

doodle & dream

Love You Mom: doodle & dream

First published in the United States in 2015 by
Bell & Mackenzie Publishing Limited

ISBN 978-1-909855-82-3

Created by Christina Rose

www.bellmackenzie.com

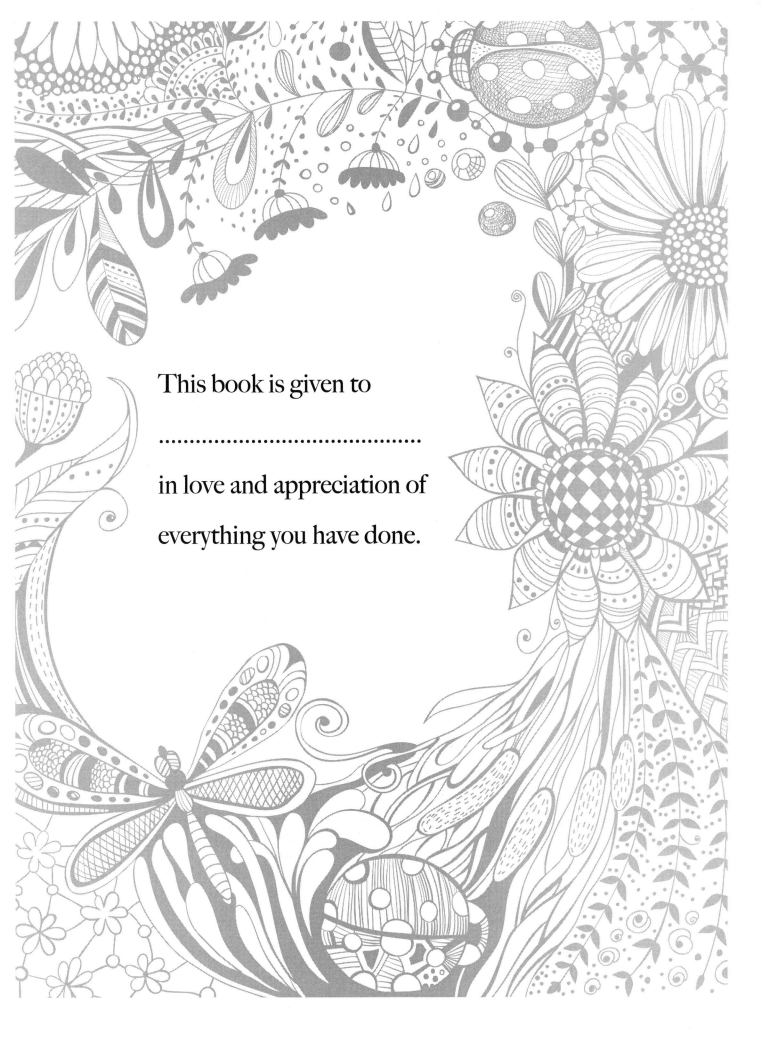

This book is given to

..

in love and appreciation of

everything you have done.

God could not be everywhere, and therefore he made mothers.

Rudyard Kipling

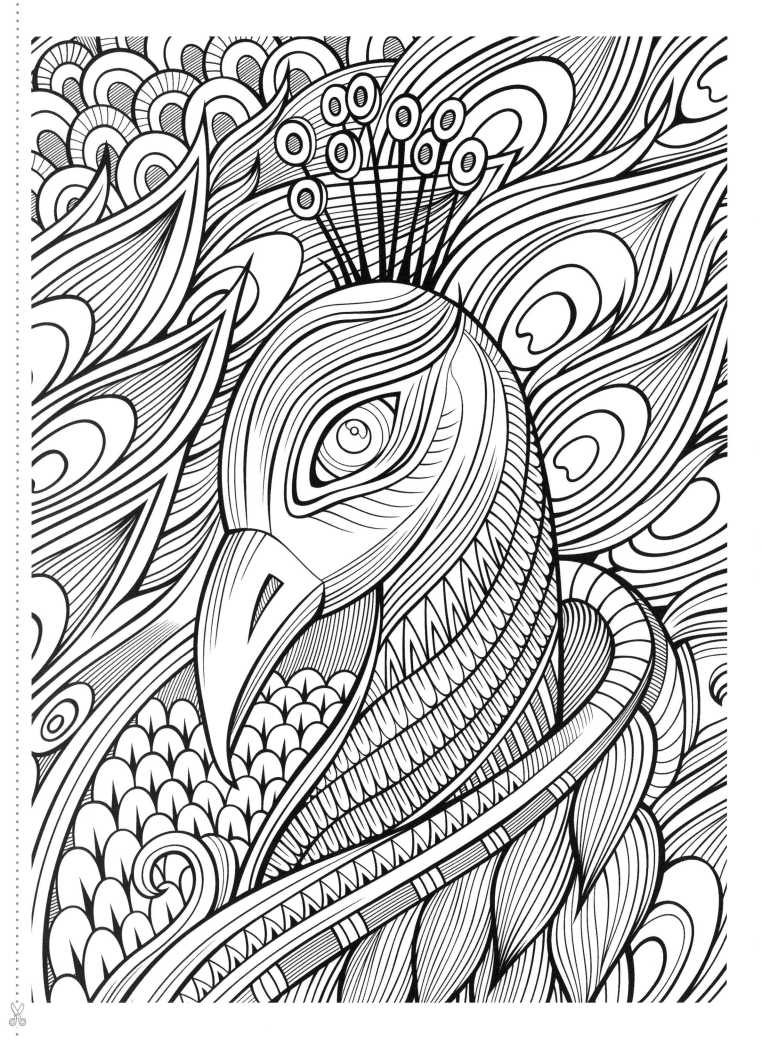

Men are what their mothers made them.

Ralph Waldo Emerson

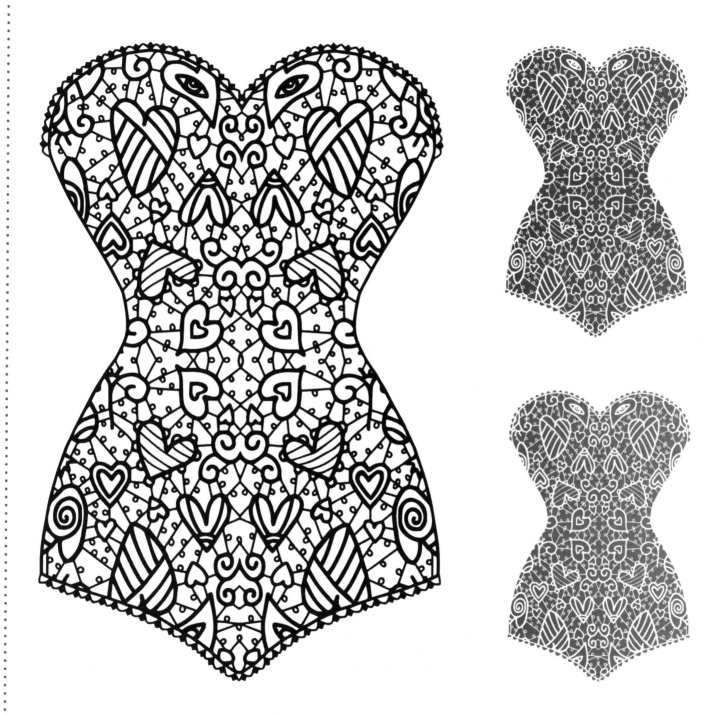

Our mothers give us so many gifts. They give us the precious gift of life, of course, but they also leave treasured lessons that can guide us along our journeys even when they are no longer with us.

Maria Shriver

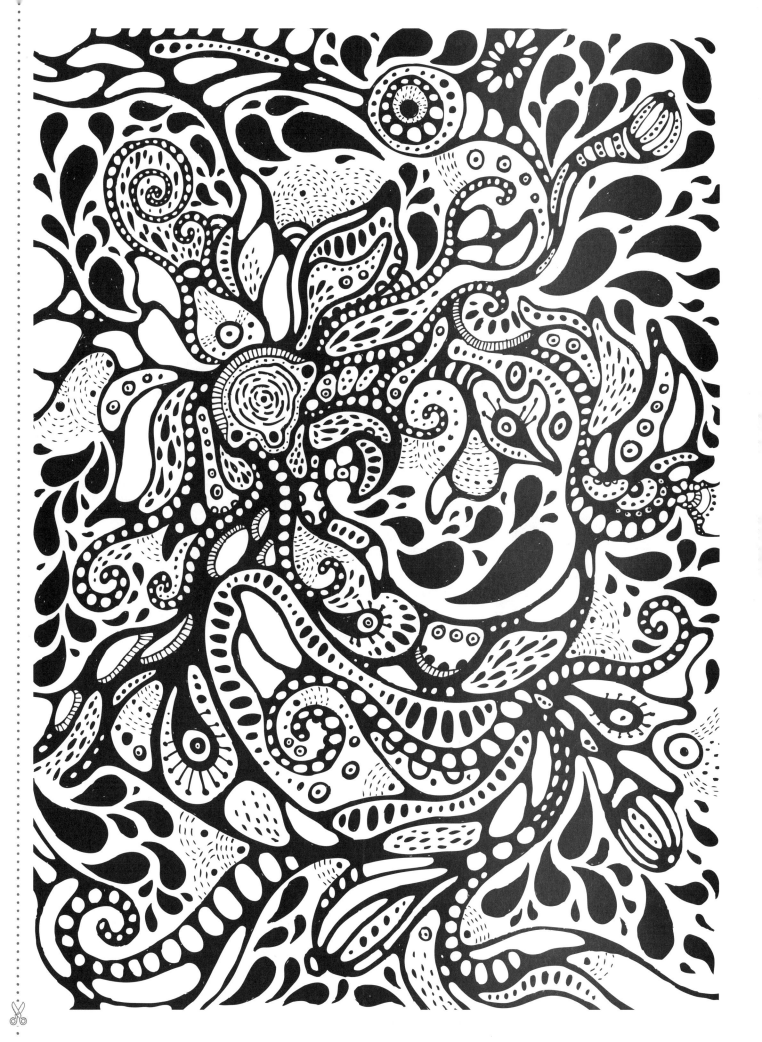

A good mother is irreplaceable.

Adriana Trigiani

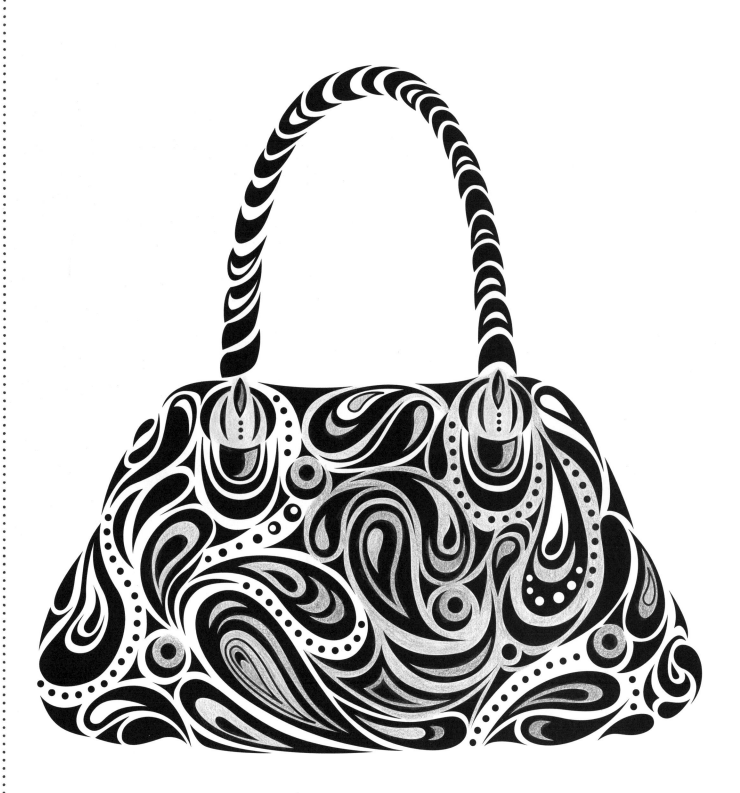

A man's work is from sun to sun, but a mother's work is never done.

Author Unknown

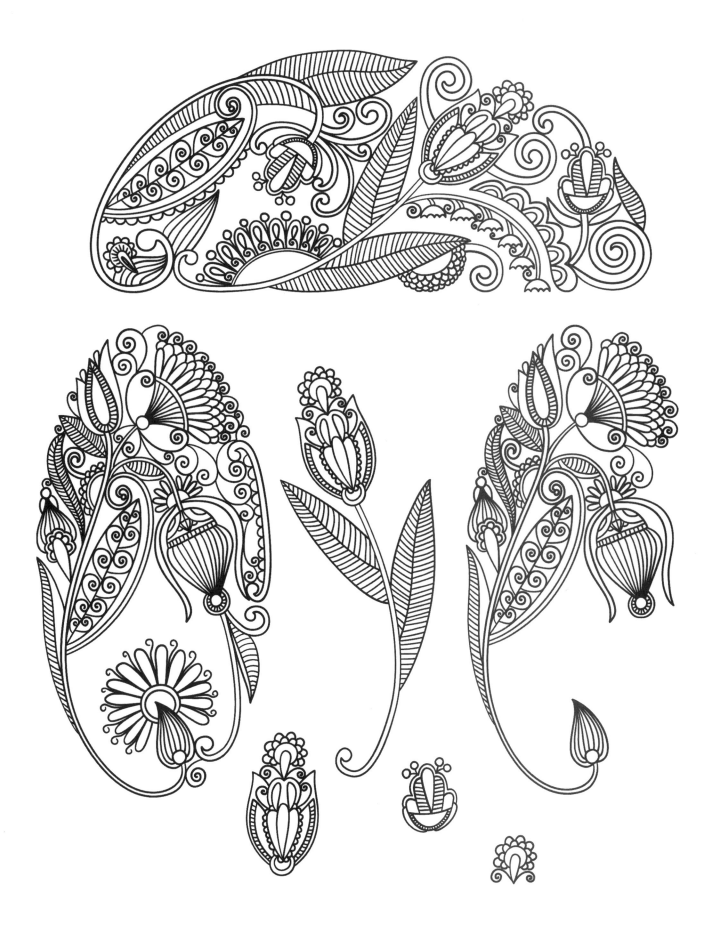

A mother is always the beginning. She is how things begin.

Amy Tan

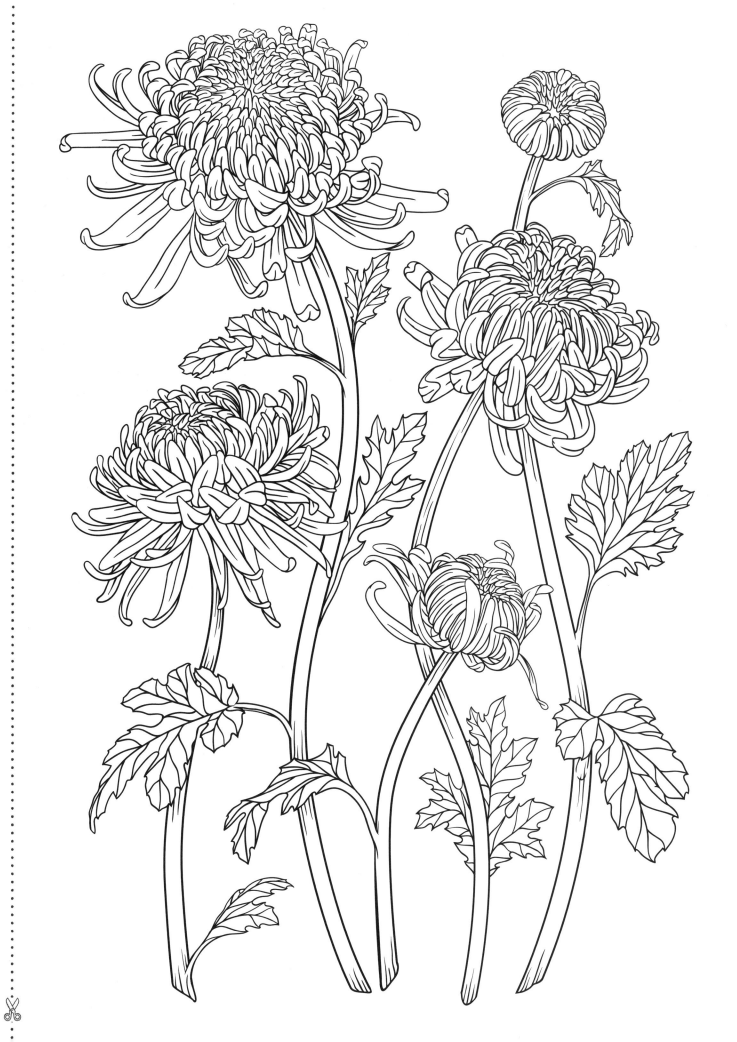

A mother is one to whom you hurry when you are troubled.

Emily Dickinson

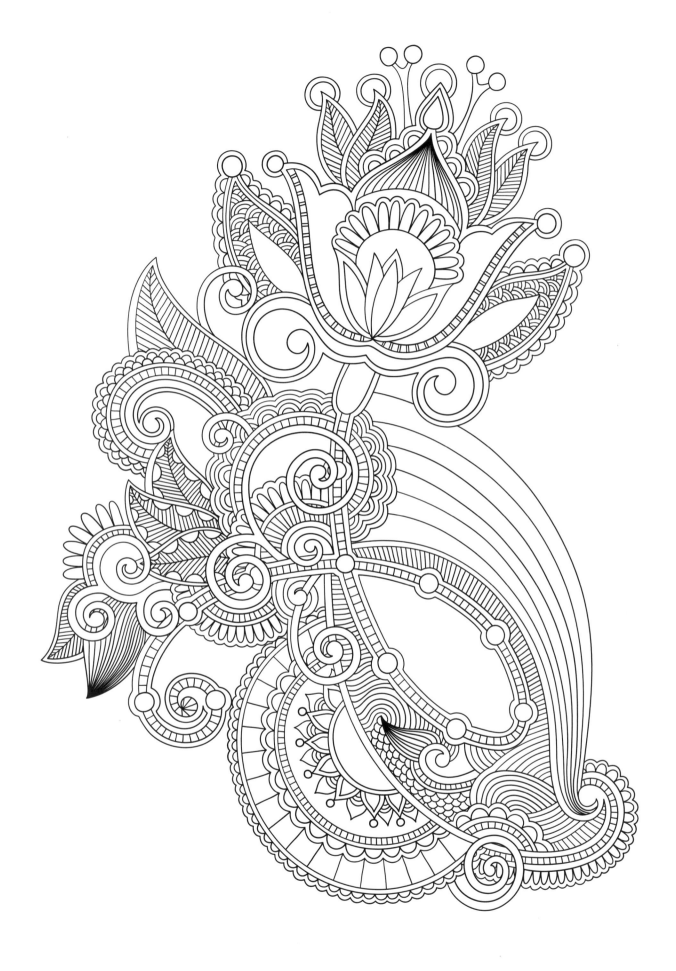

A mother is the truest friend we have, when trials heavy and sudden, fall upon us.

Washington Irving

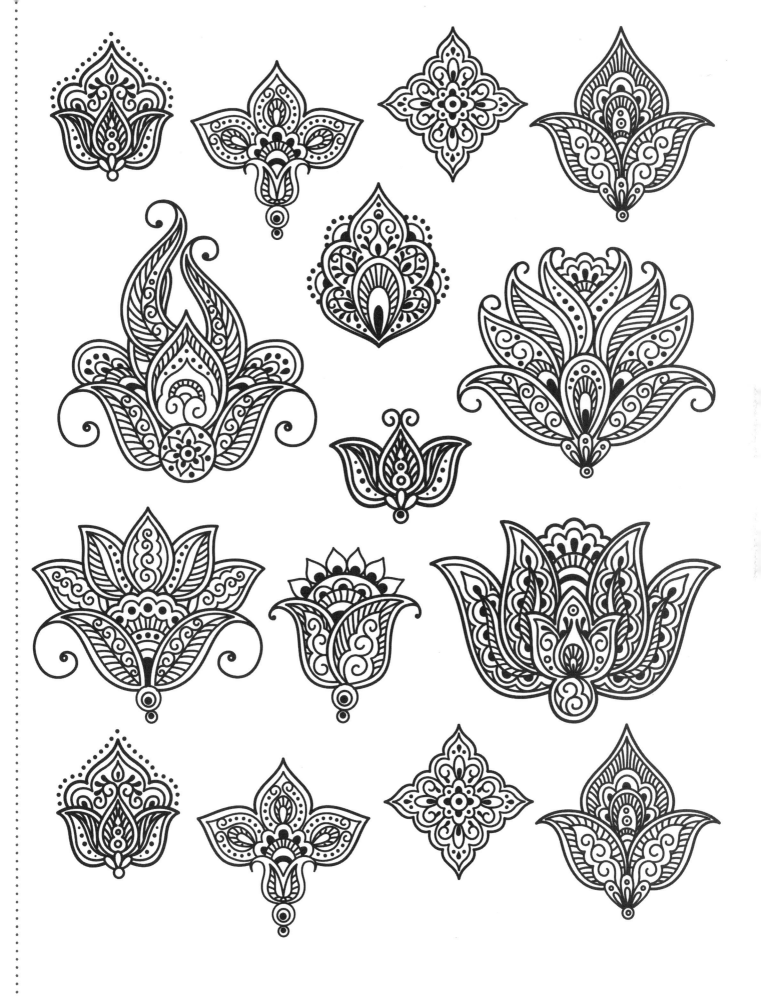

A mother understands what a child does not say.

Jewish proverb

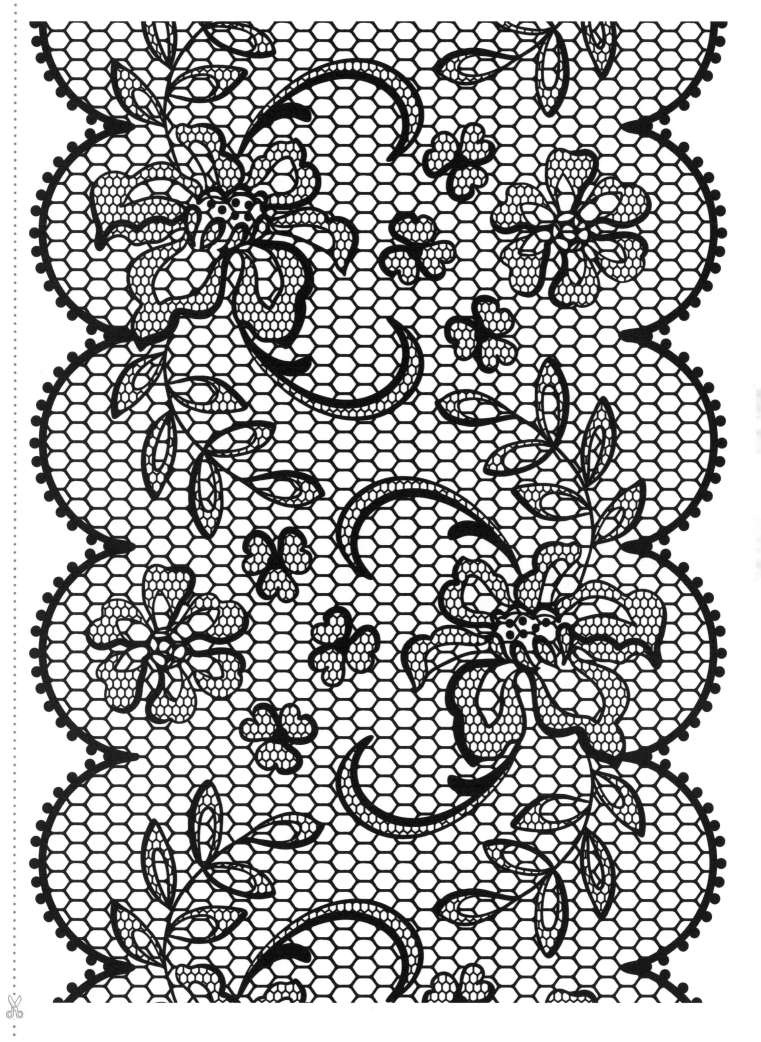

A mother's arms are made of tenderness and children sleep soundly in them.

Victor Hugo

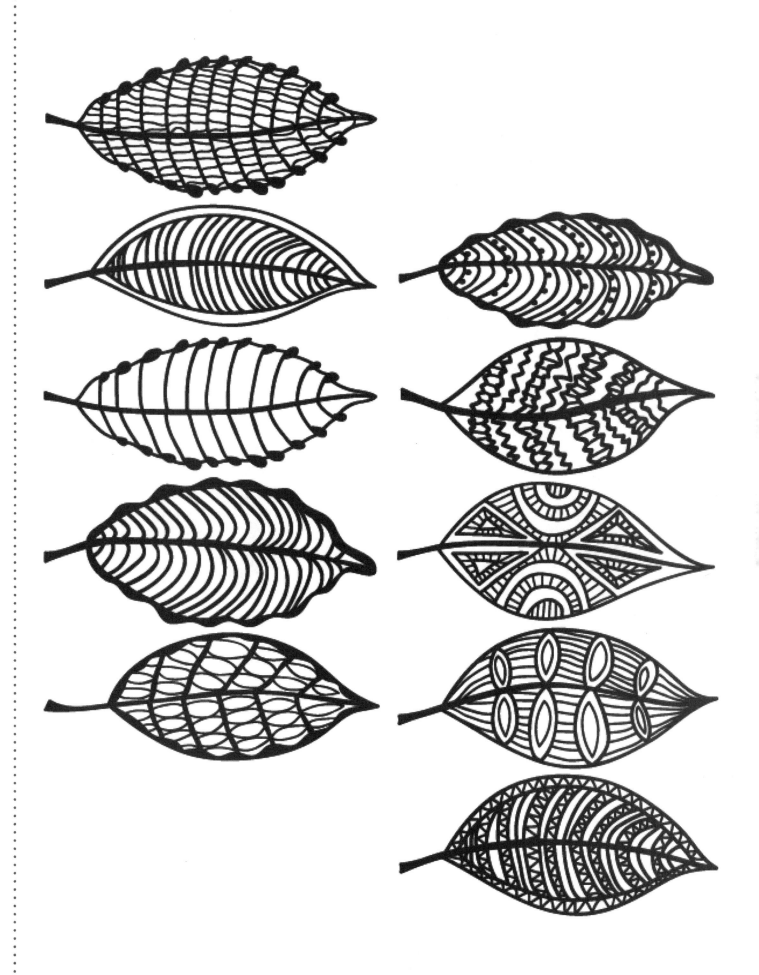

A mother's happiness is like a beacon, lighting up the future but reflected also on the past in the guise of fond memories.

Honore de Balzac

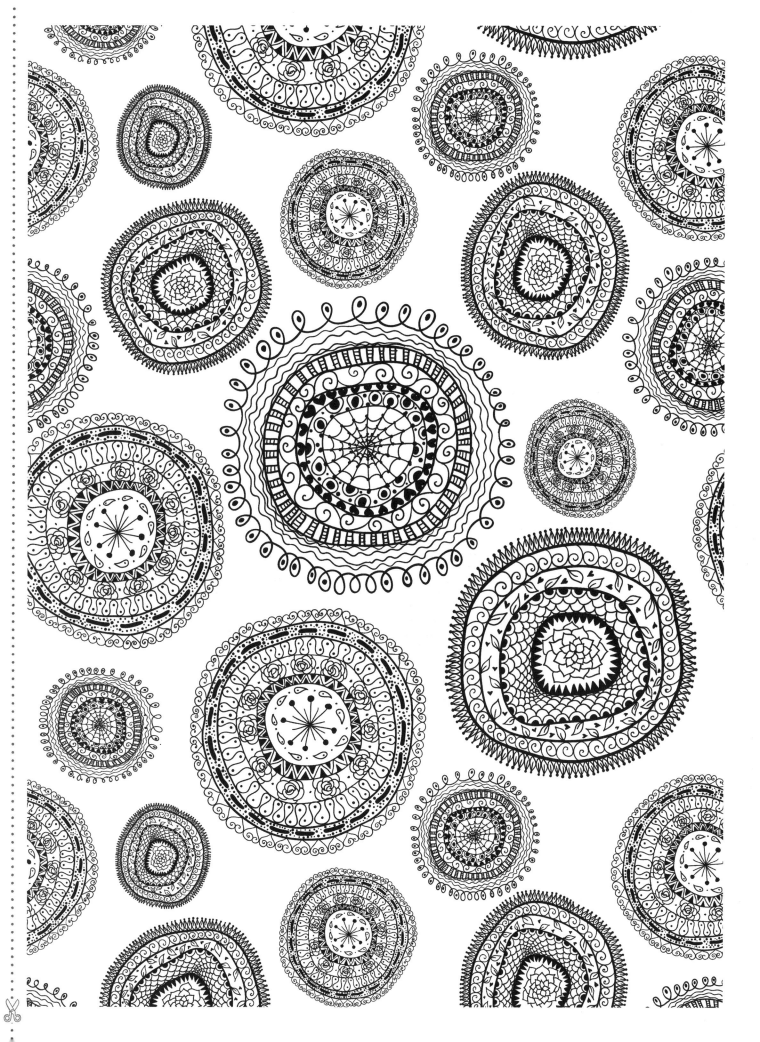

Motherhood is the greatest thing and the hardest thing.

Ricki Lake

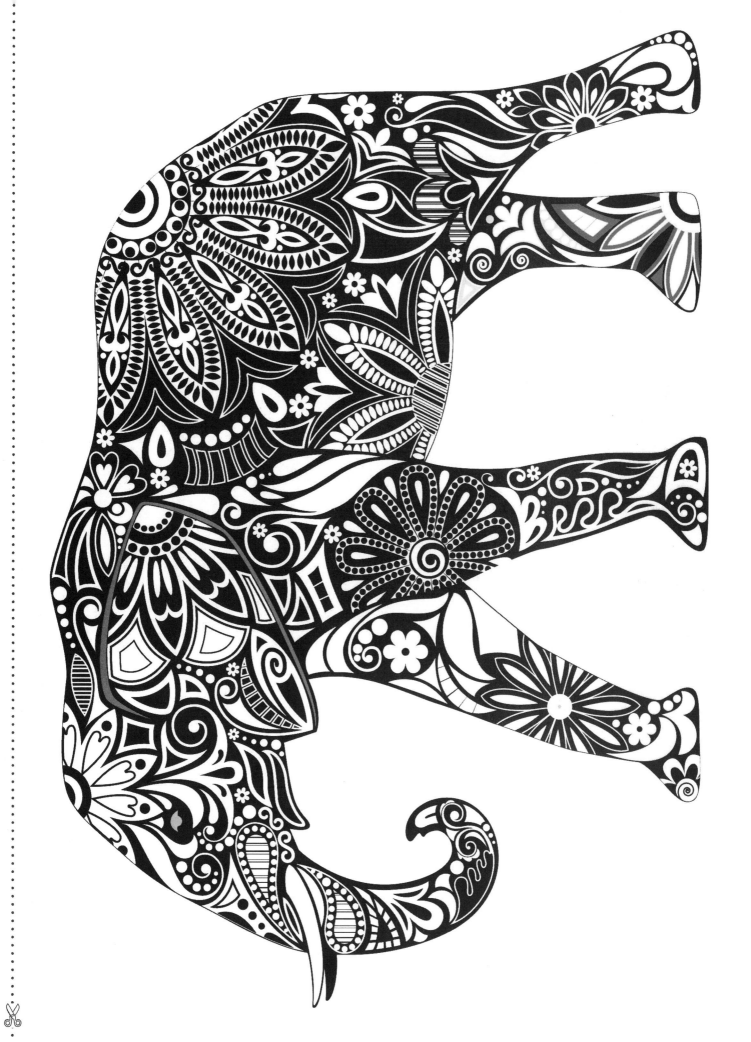

All that I am or ever hope to be, I owe to my angel mother.

Abraham Lincoln

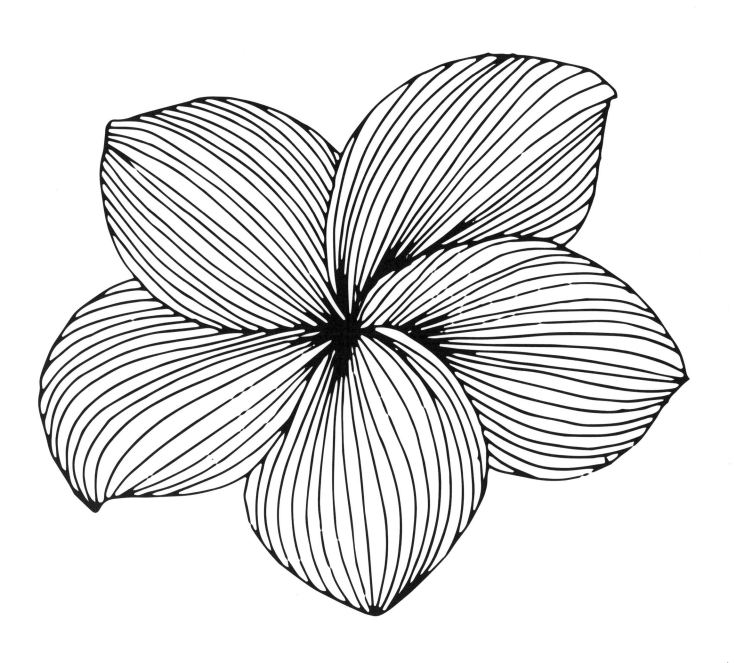

And so our mothers and grandmothers have, more often than not anonymously, handed on the creative spark, the seed of the flower they themselves never hoped to see – or like a sealed letter they could not plainly read.

Alice Walker

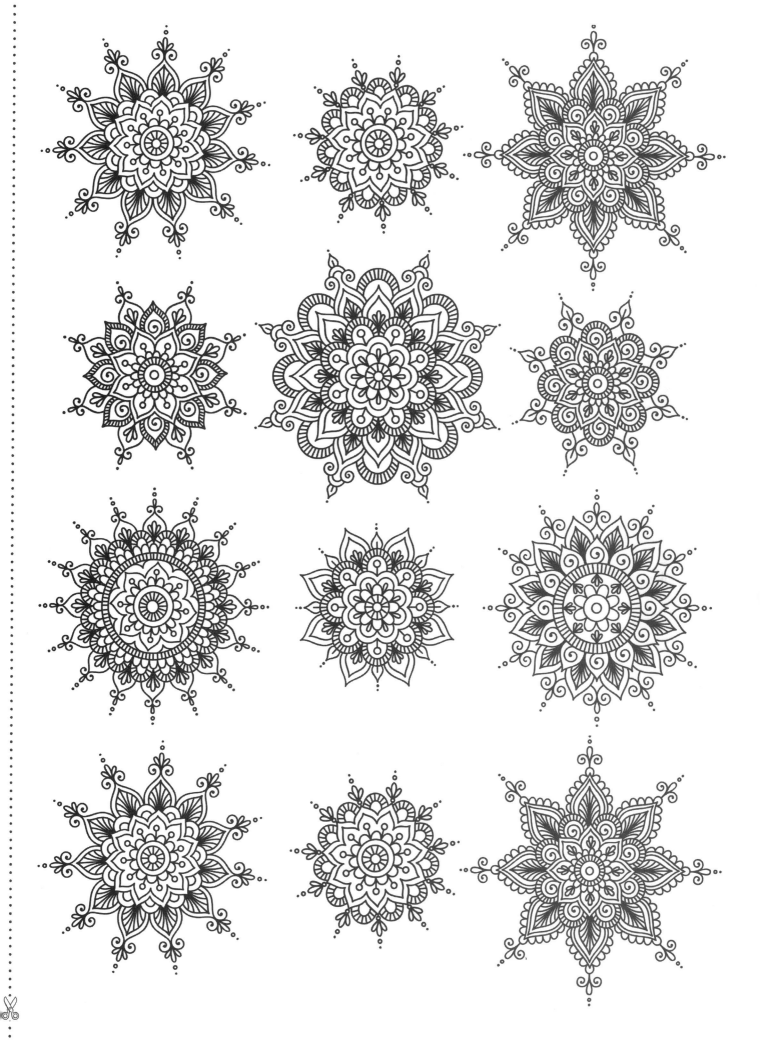

Biology is the least of what makes someone a mother.

Oprah Winfrey

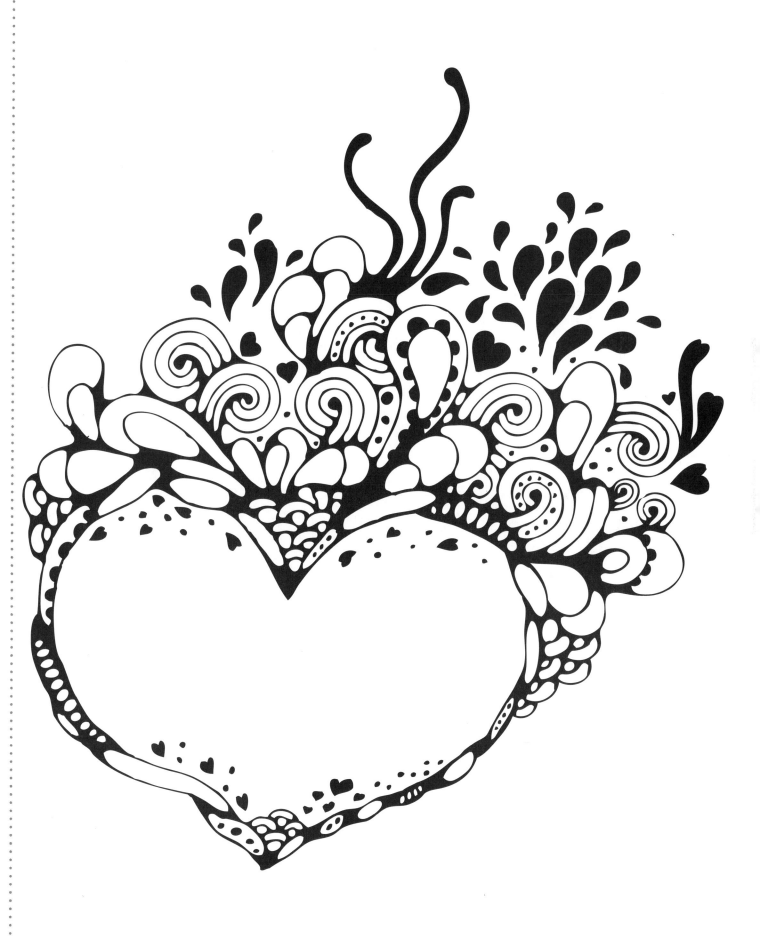

Blessed is a mother that would give up part of her soul for her children's happiness.

Shannon L. Alder

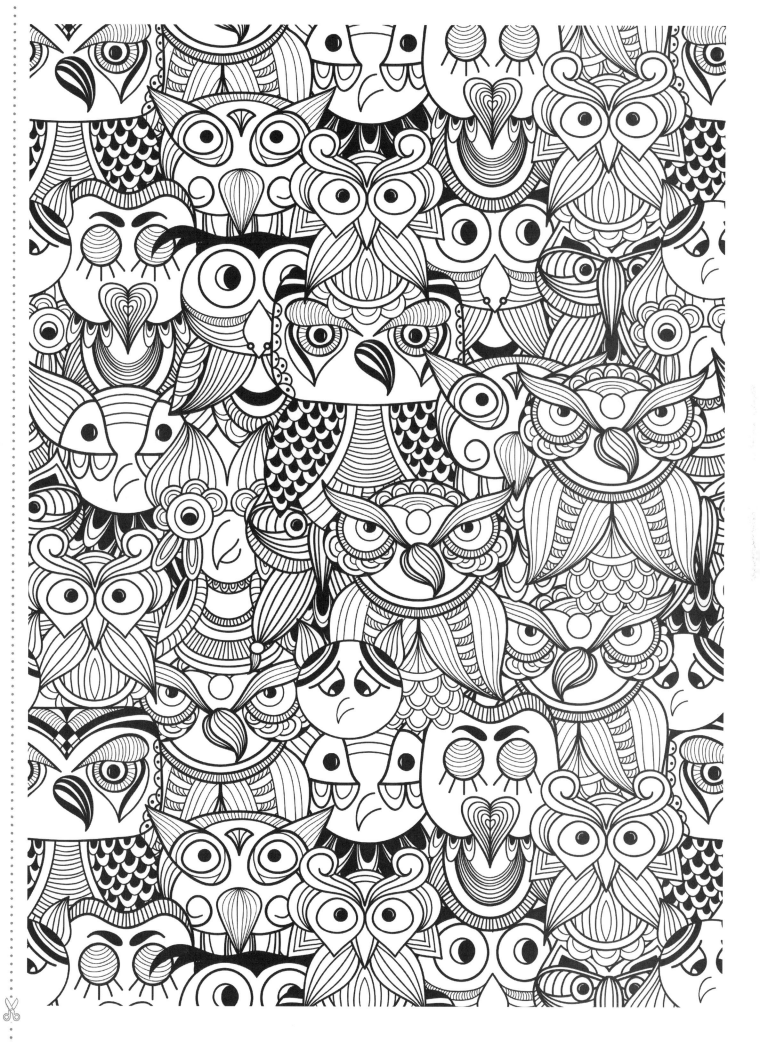

By and large, mothers and housewives are the only workers who do not have regular time off. They are the great vacation-less class.

Anne Morrow Lindbergh

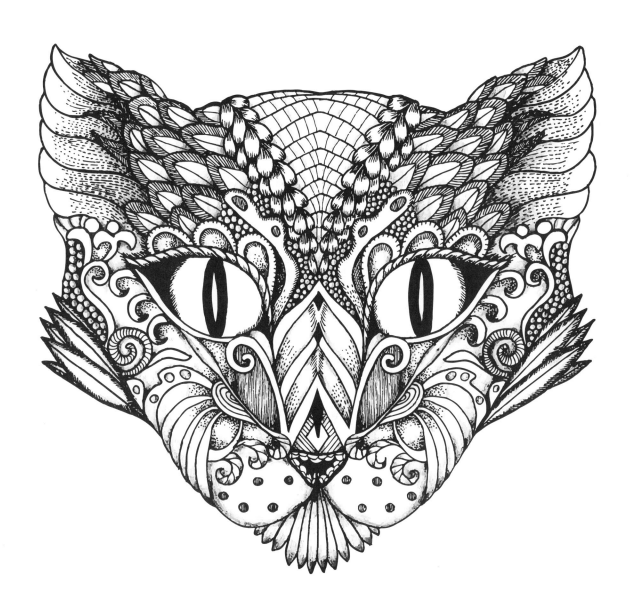

Grown don't mean nothing to a mother. A child is a child.

Toni Morrison

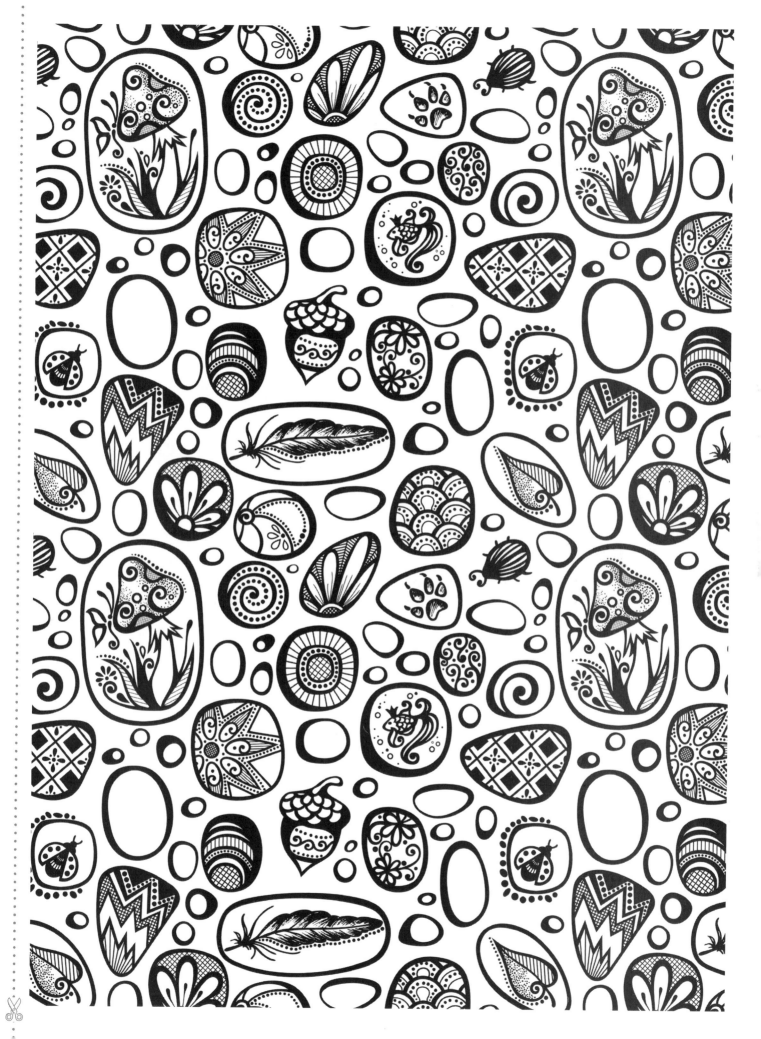

I am sure that if the mothers of various nations could meet, there would be no more wars.

E. M. Forster

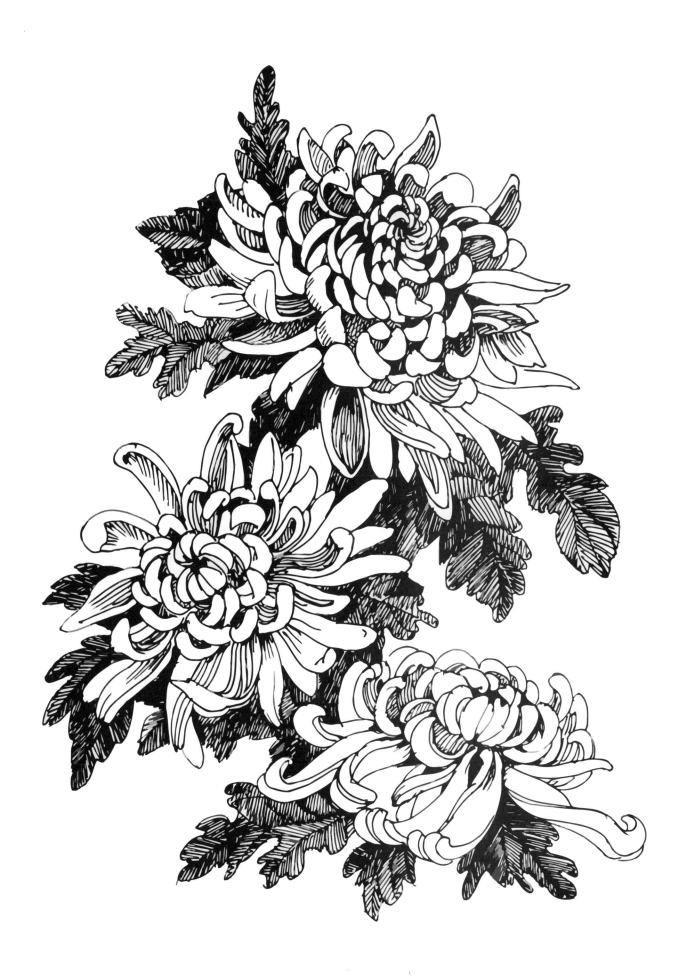

I realised when you look at your mother, you are looking at the purest love you will ever know.

Mitch Albom

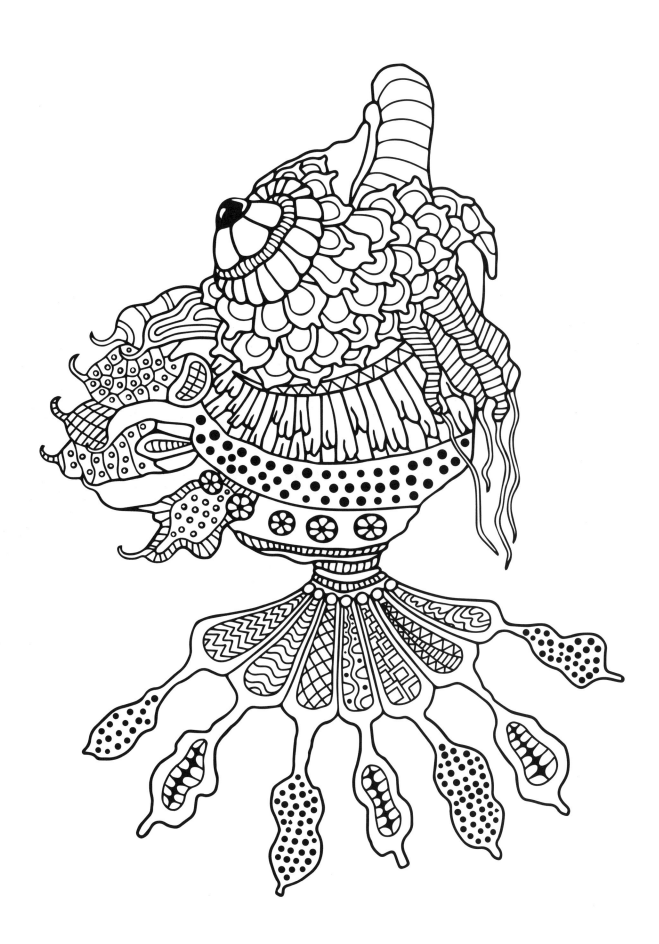

I remember my mother's prayers and they have always followed me. They have clung to me all my life.

Abraham Lincoln

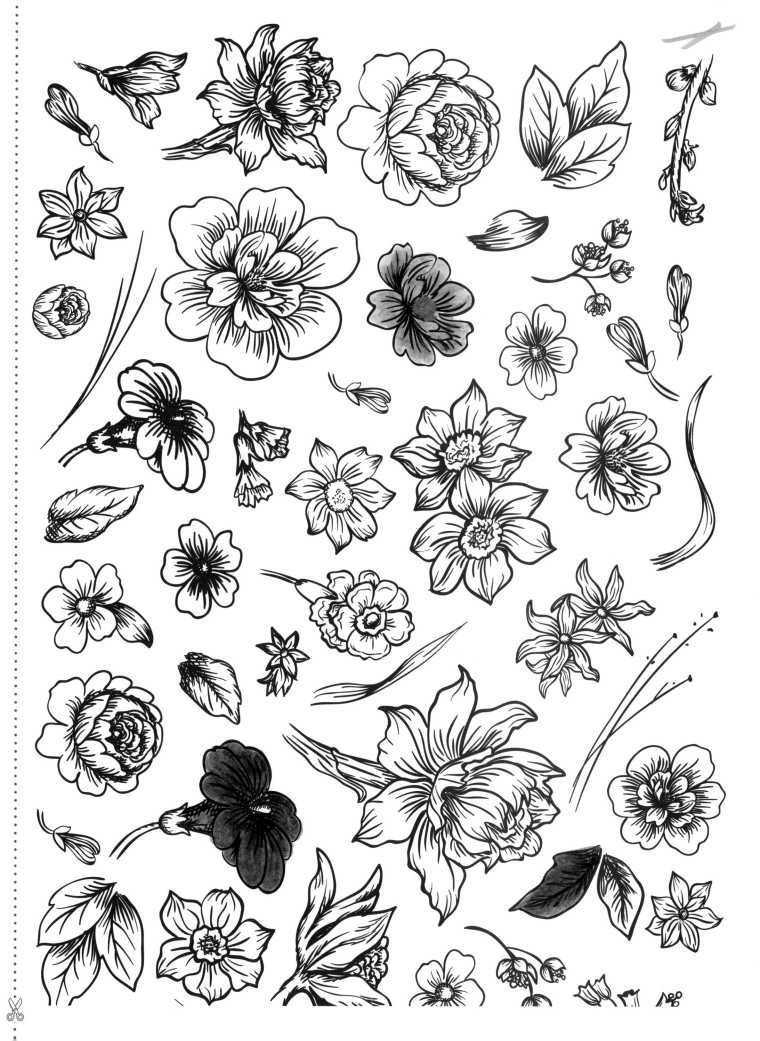

If I had a single flower for every time I think of you, I could walk forever in my garden.

Claudia Adrienne Grandi

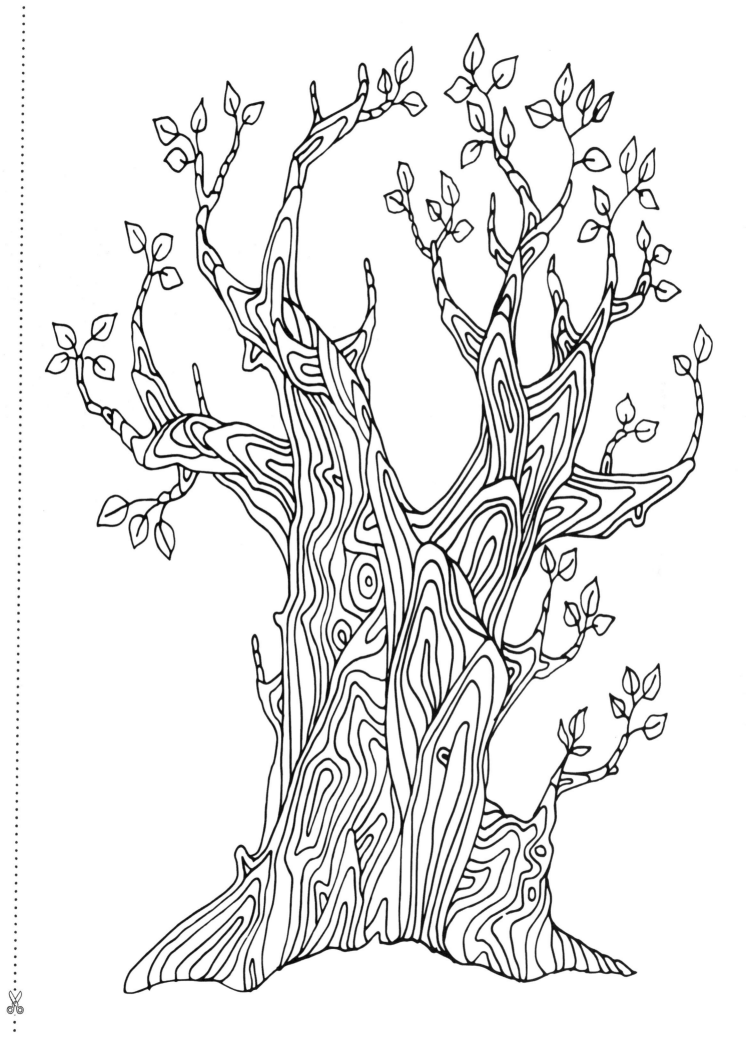

It kills you to see them grow up. But I guess it would kill you quicker if they didn't.

Barbara Kingsolver

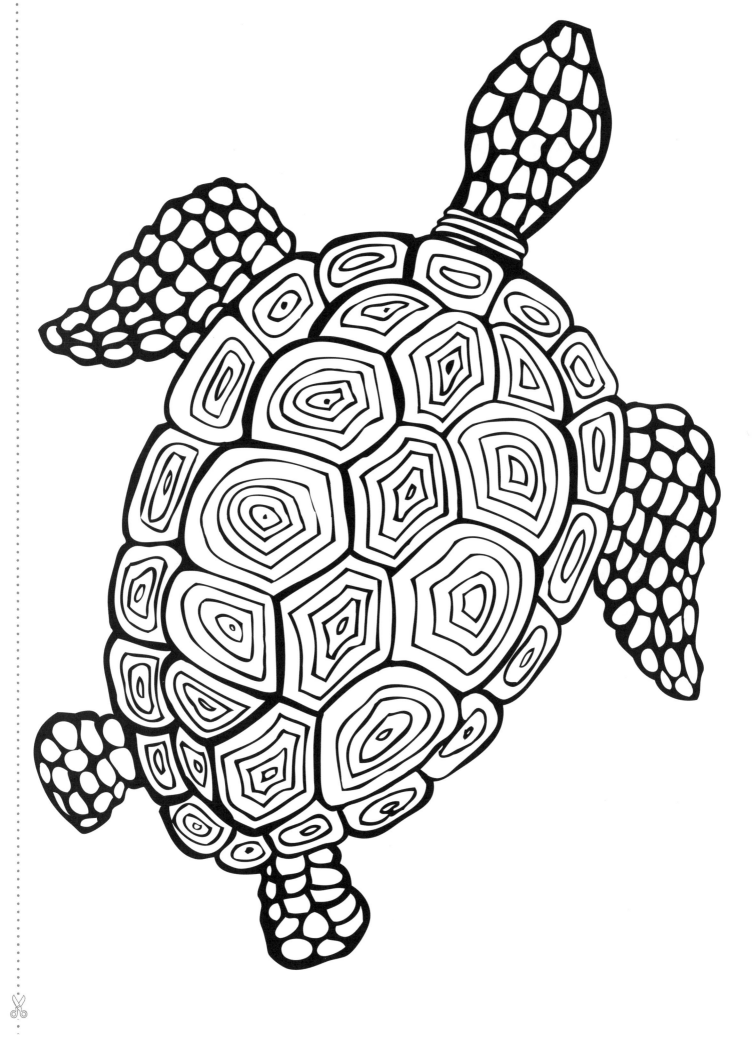

Life began with waking up and loving my mother's face.

George Eliot

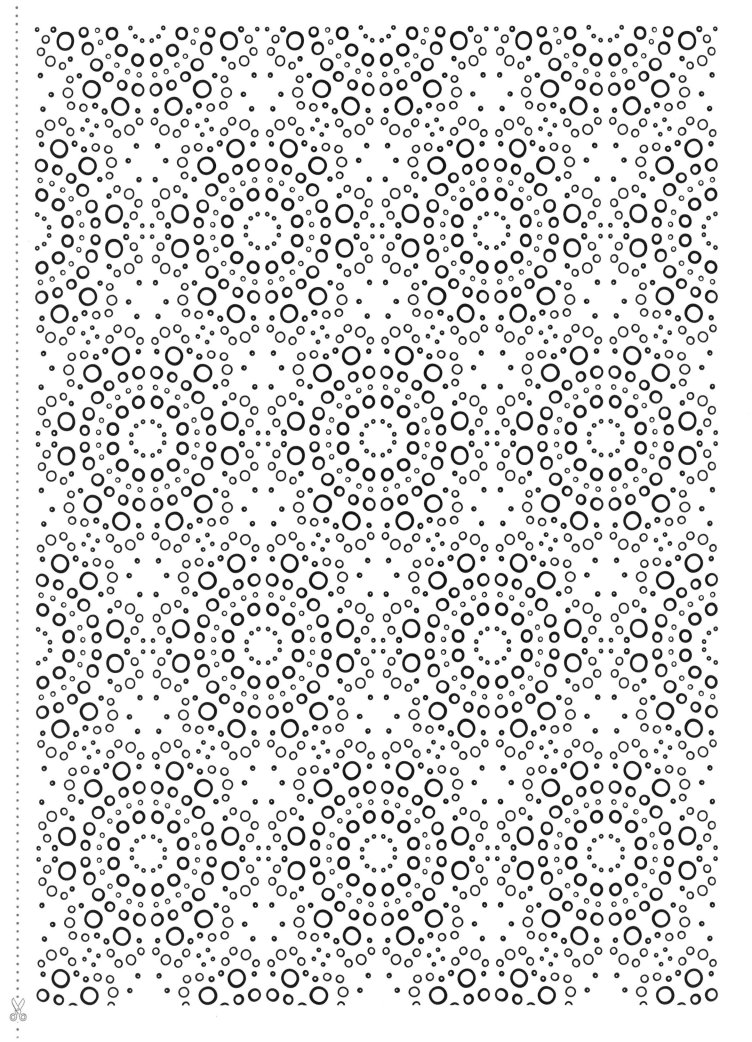

Love as powerful as your mother's for you leaves its own mark ... to have been loved so deeply ... will give us some protection forever.

J.K. Rowling

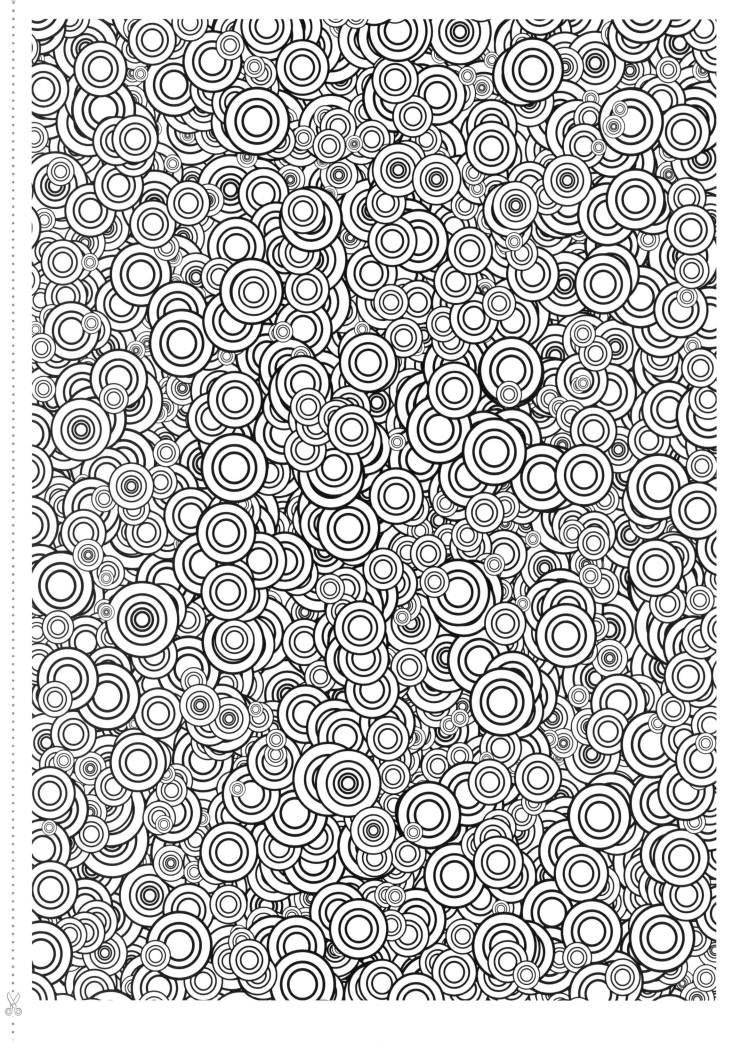

Making the decision to have a child is momentous. It is to decide forever to have your heart go walking around outside your body.

Elizabeth Stone

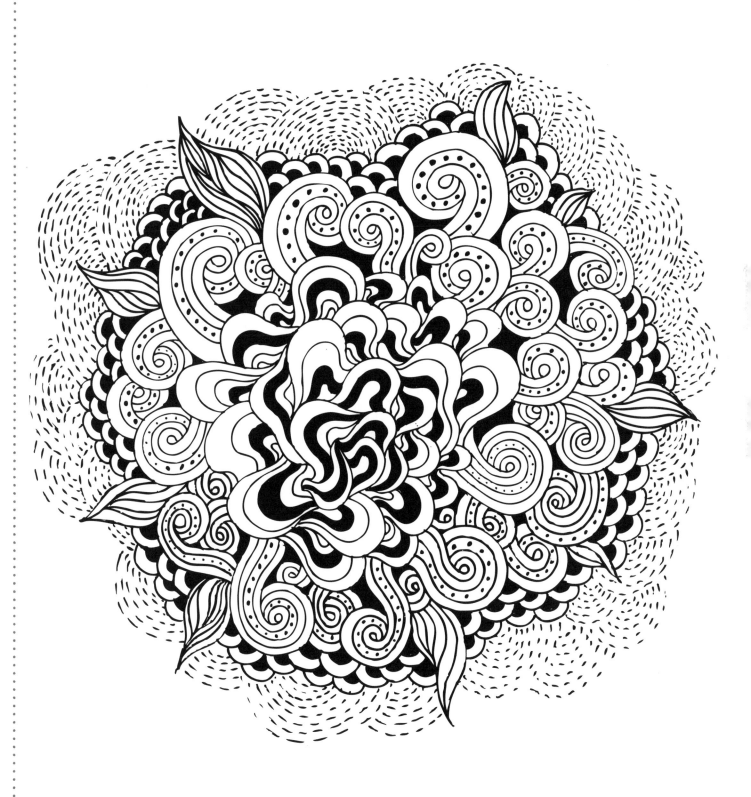

Mother is the name for God in the lips and hearts of little children.

William Makepeace Thackeray

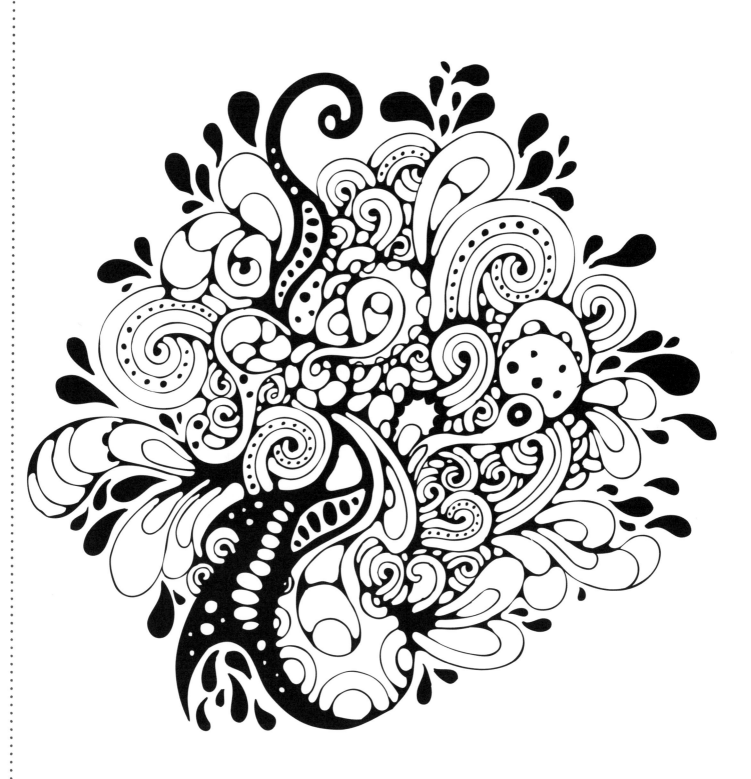
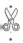

Mother love is the fuel that enables a normal human being to do the impossible.

Marion C. Garretty

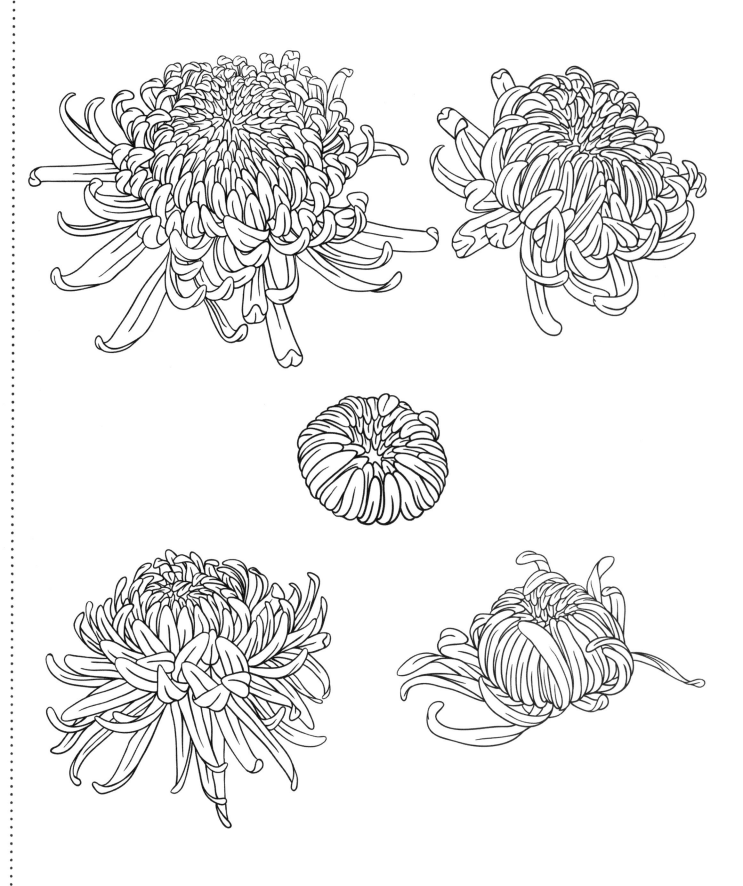

Mother - that was the bank where we deposited all our hurts and worries.

T. DeWitt Talmage

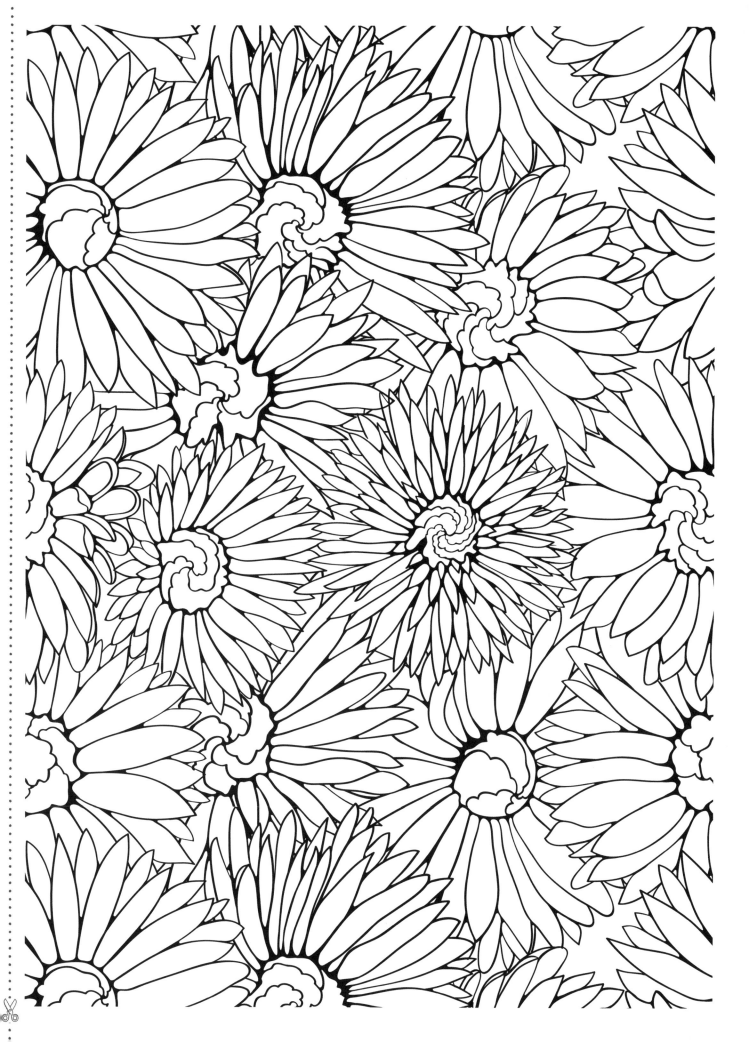

Mother, the ribbons of your love are woven around my heart.

Author Unknown

Mothers and their children are in a category all their own. There's no bond so strong in the entire world. No love so instantaneous and forgiving.

Gail Tsukiyama

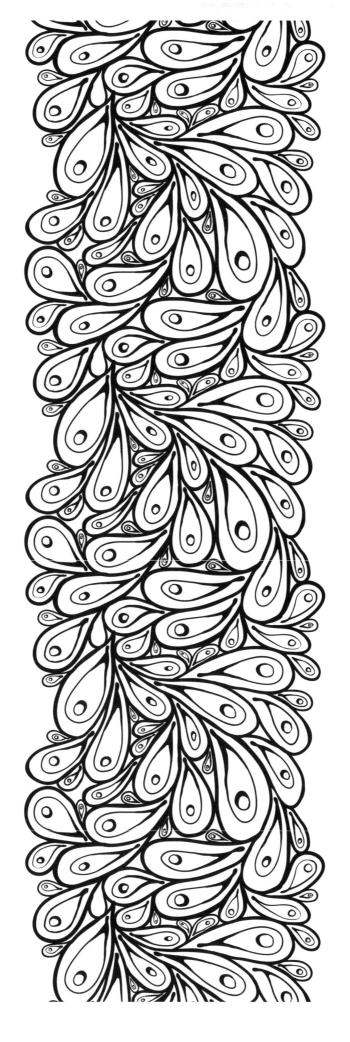

Mothers are the people who love us for no good reason. And those of us who are mothers know it's the most exquisite love of all.

Maggie Gallagher

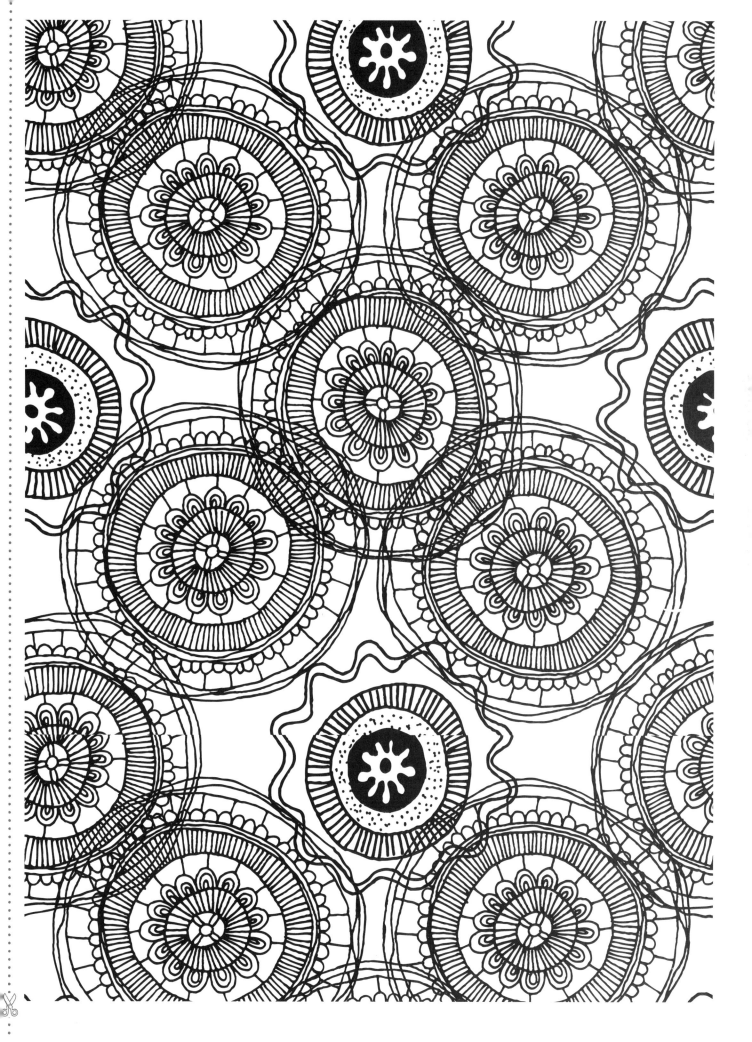

Mothers hold their children's hands for a short while, but their hearts forever.

Author Unknown

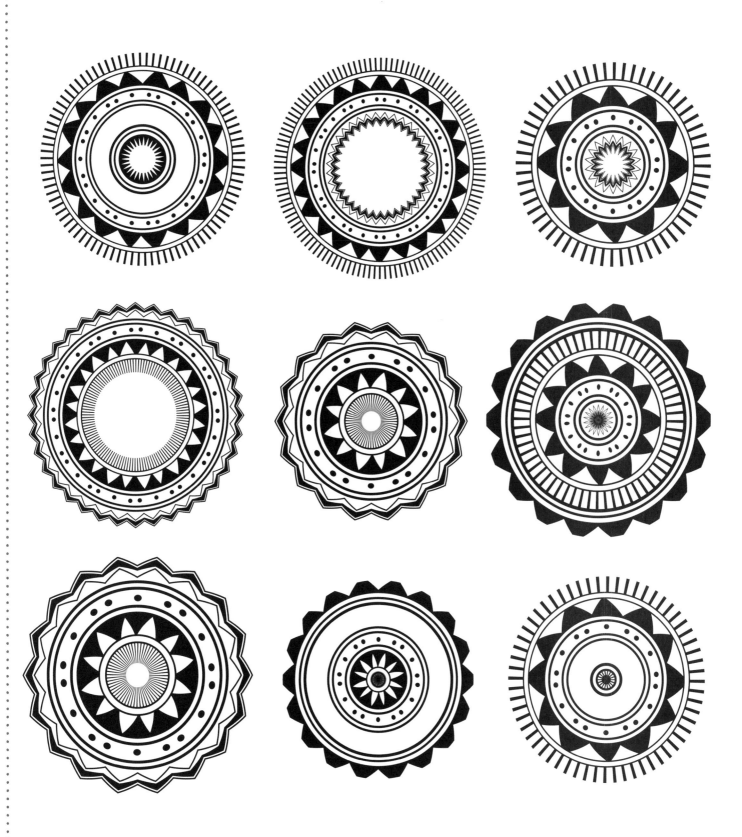

Mothers were the only ones you could depend on to tell the whole, unvarnished truth.

Margaret Dilloway

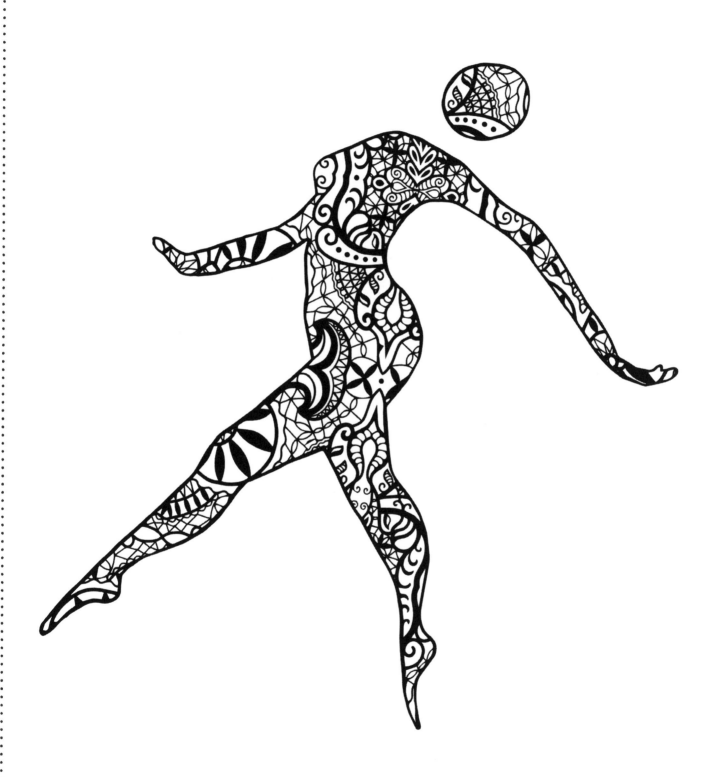

Mother's love is bliss, is peace, it need not be acquired, it need not be deserved. If it is there, it is like a blessing; if it is not there it is as if all the beauty had gone out of life.

Erich Fromm

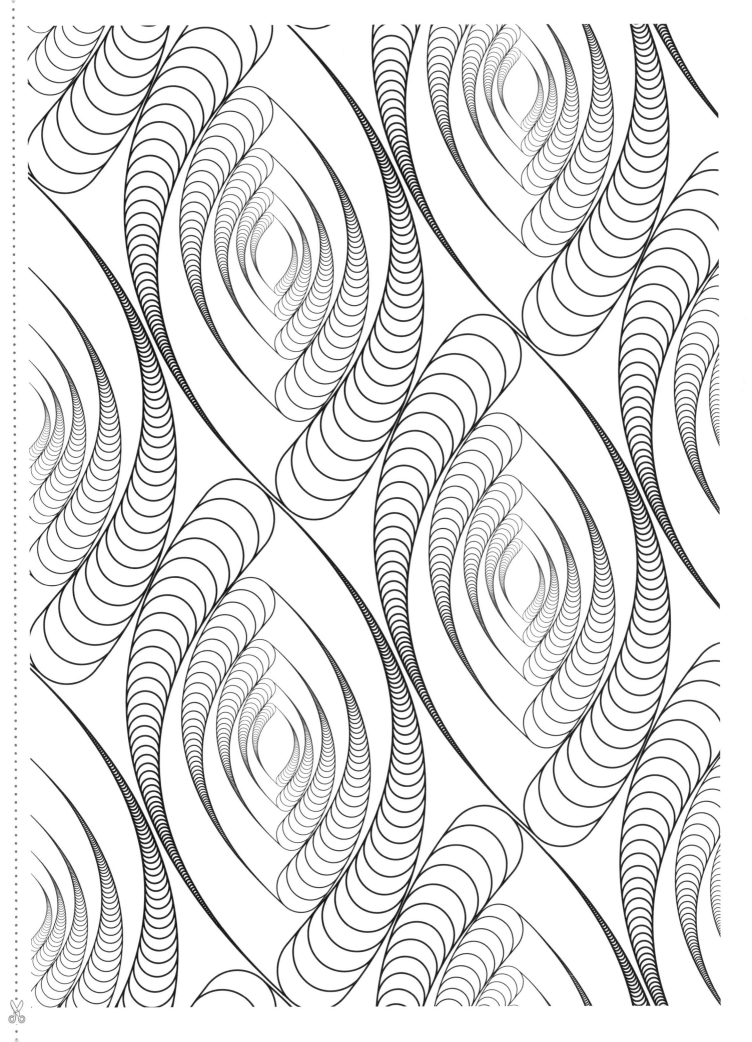

My mother… she is beautiful, softened at the edges and tempered with a spine of steel. I want to grow old and be like her.

Jodi Picoult

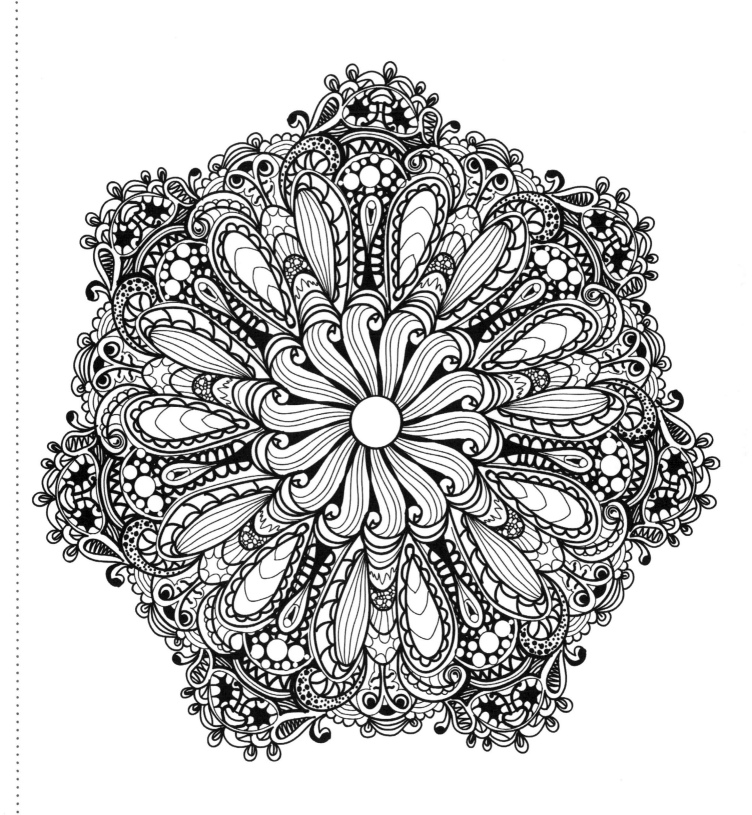

Only mothers can think of the future - because they give birth to it in their children.

Maxim Gorky

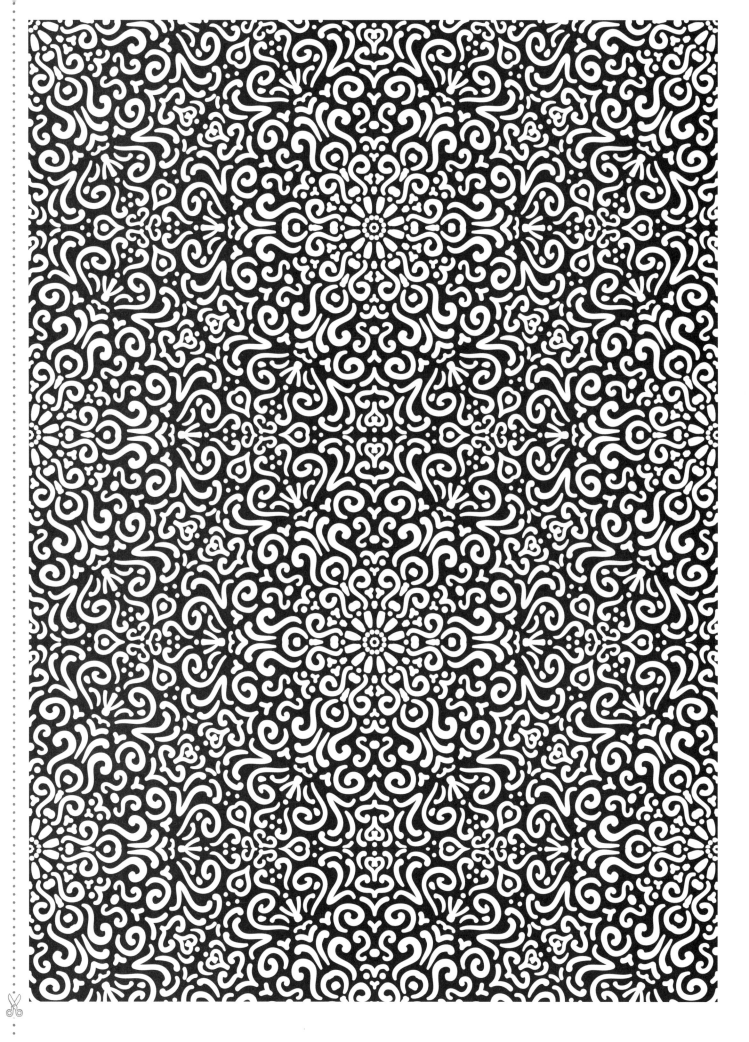

She raised us with humour, and she raised us to understand that not everything was going to be great - but how to laugh through it.

Liza Minnelli

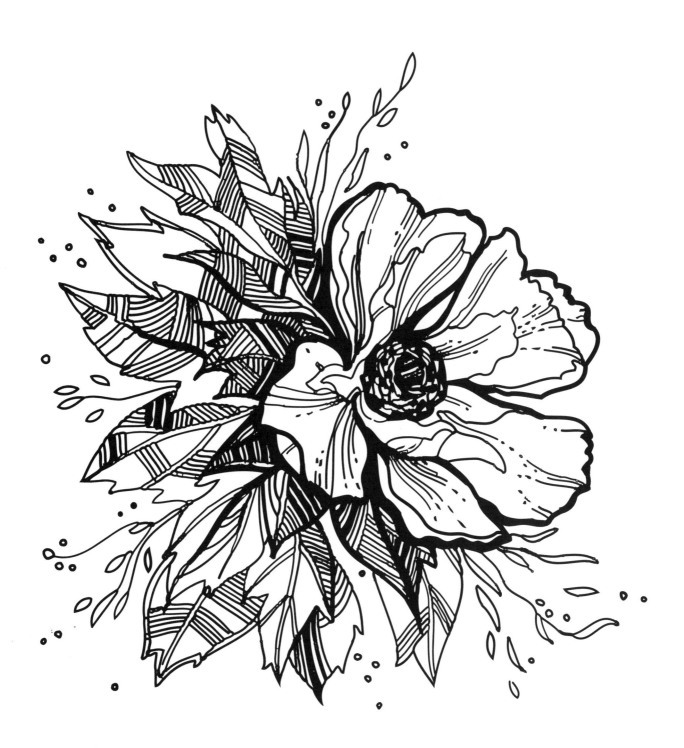

Some are kissing mothers and some are scolding mothers, but it is love just the same, and most mothers kiss and scold together.

Pearl S. Buck

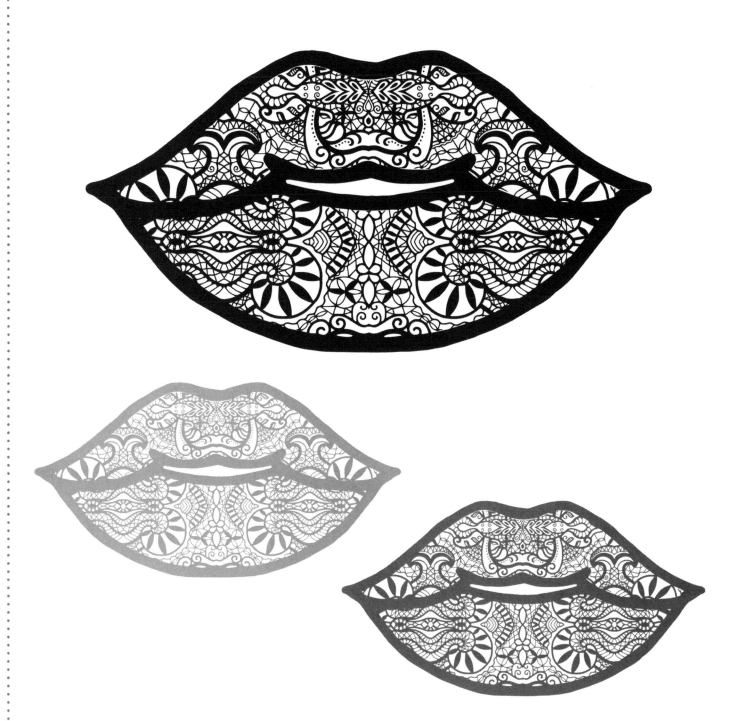

The heart of a mother is a deep abyss at the bottom of which you will always find forgiveness.

Honoré de Balzac

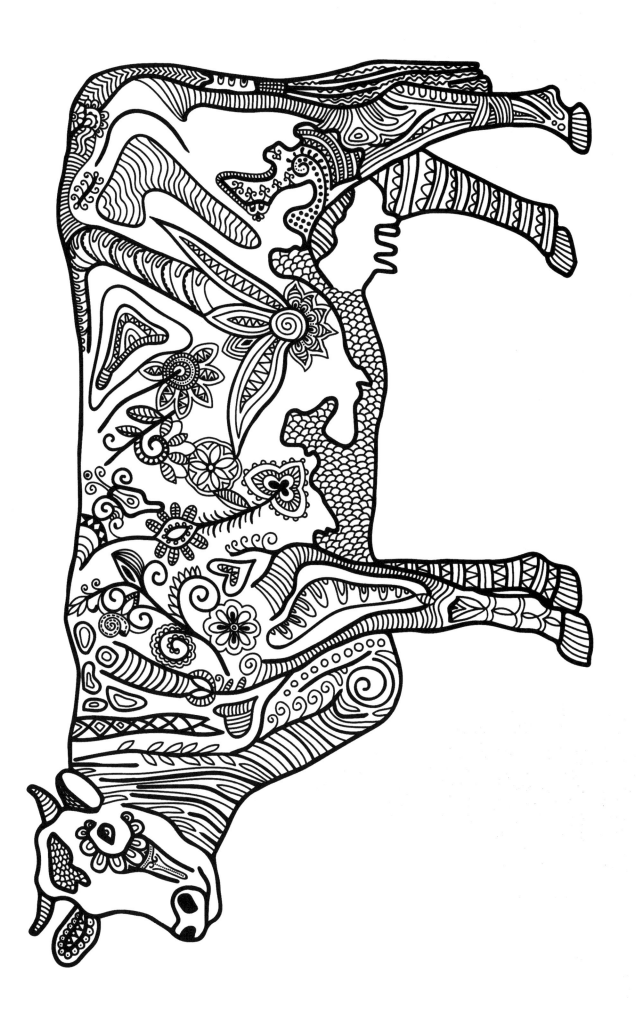

The moment a child is born, the mother is also born. She never existed before. The woman existed, but the mother, never. A mother is something absolutely new.

Rajneesh

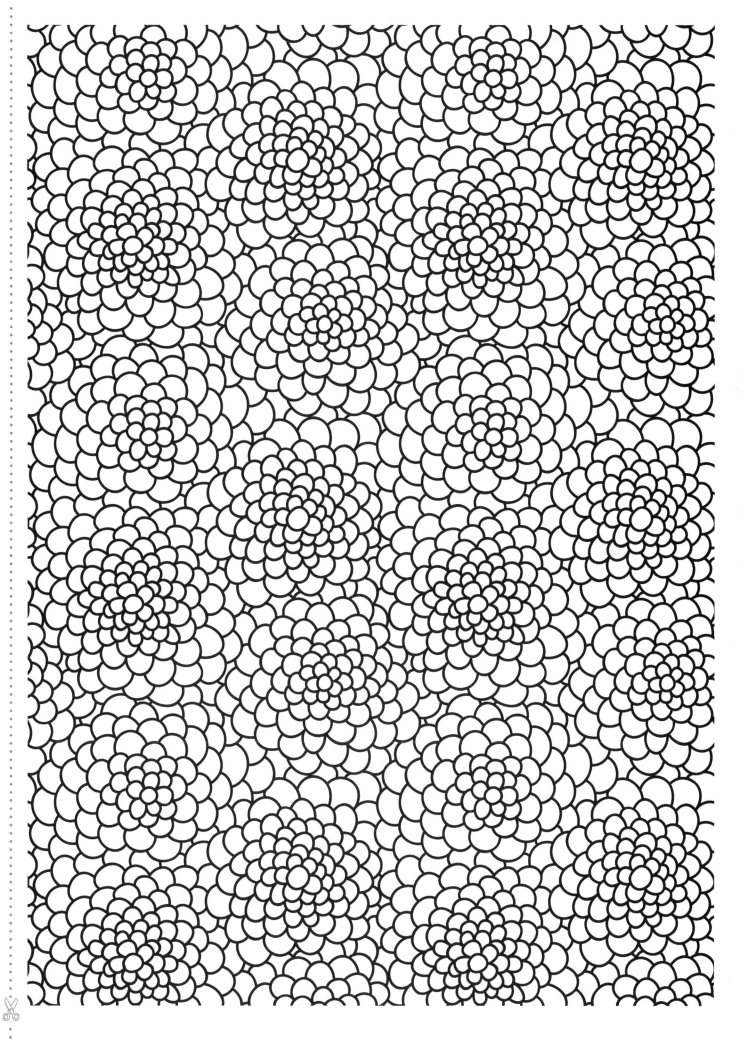

There is only one pretty child in the world, and every mother has it.

Chinese Proverb

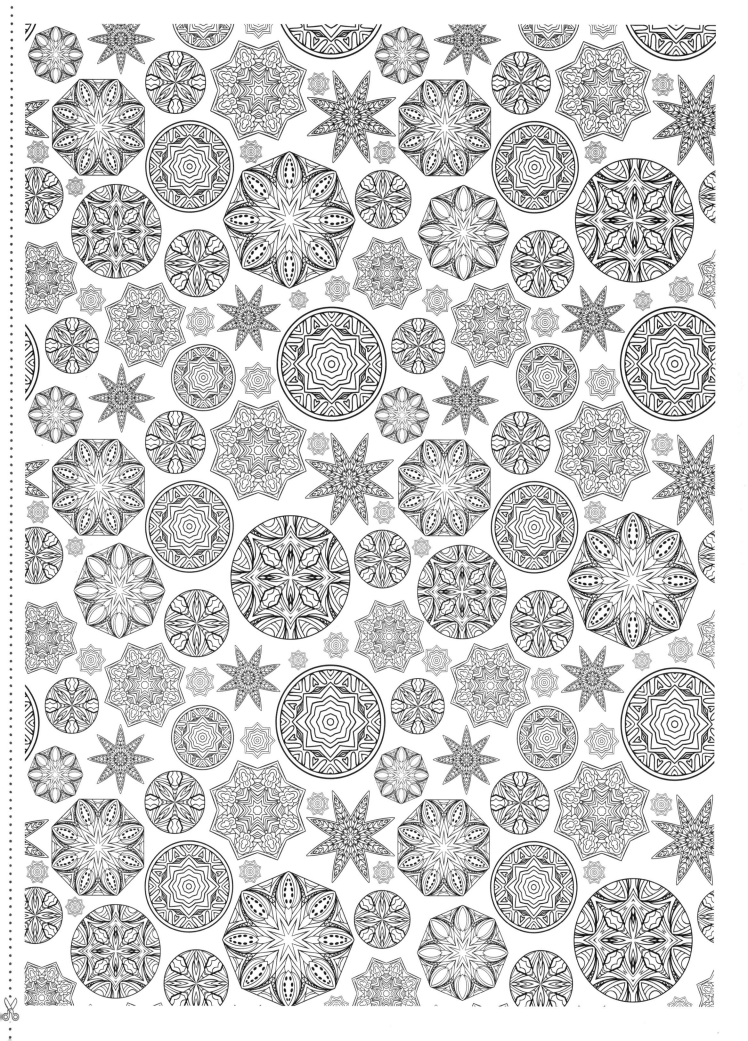

There's no way to be a perfect mother and a million ways to be a good one.

Jill Churchill

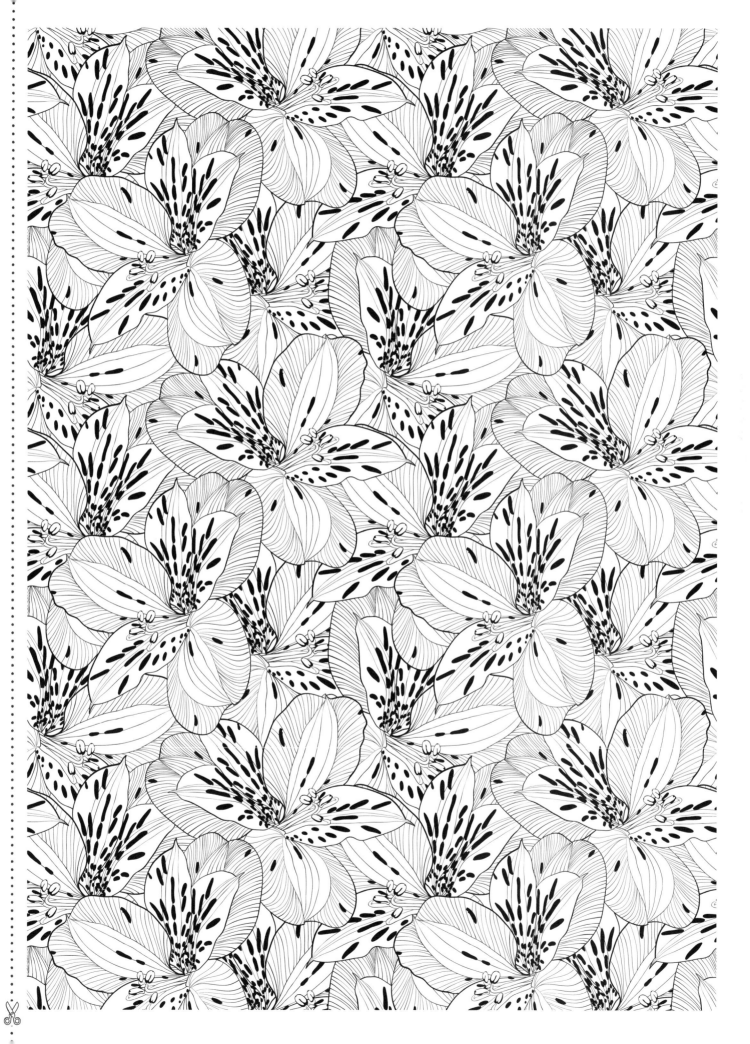

This is what we do, my mother's life said. We find ourselves in the sacrifices we make.

Cammie McGovern

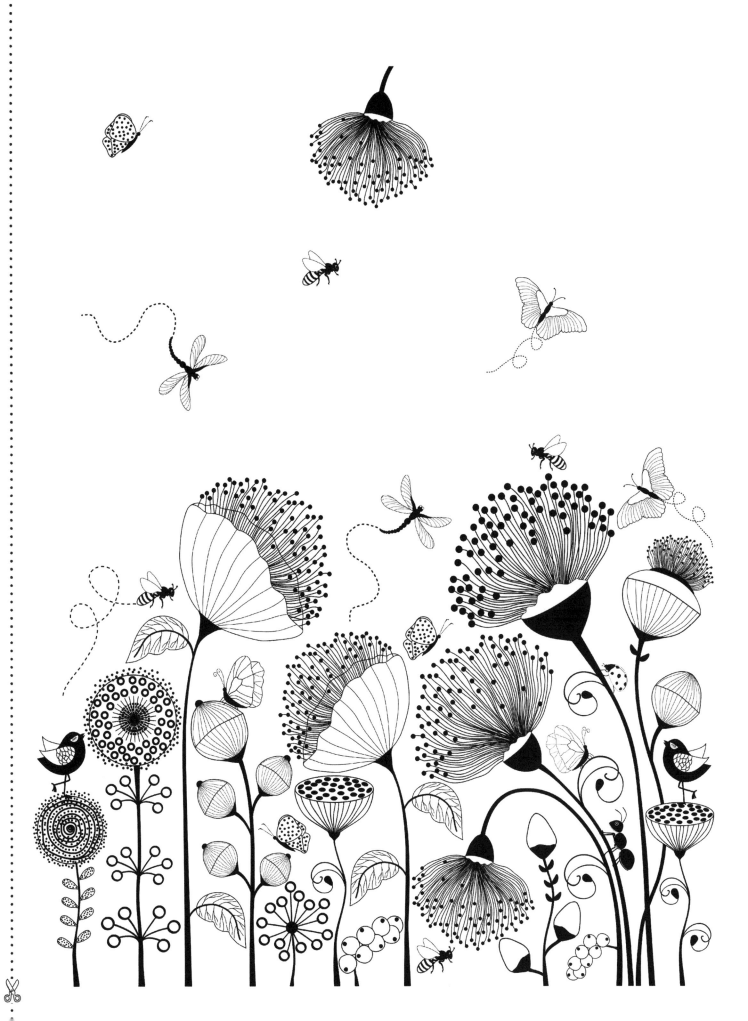

When I stopped seeing my mother with the eyes of a child, I saw the woman who helped me give birth to myself.

Nancy Friday

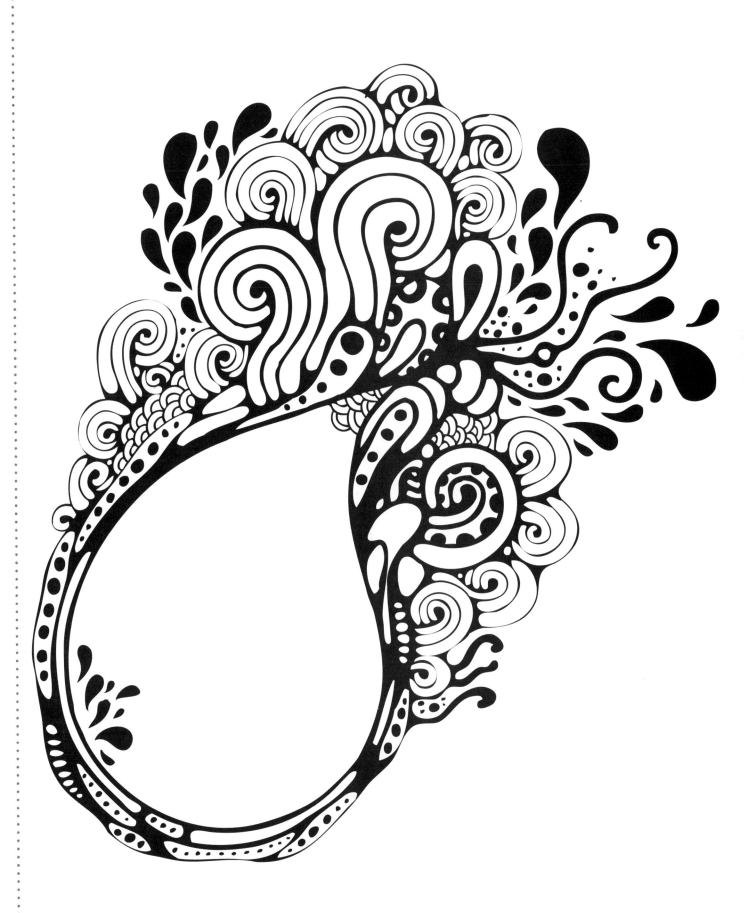

When you are a mother, you are never really alone in your thoughts. A mother always has to think twice, once for herself and once for her child.

Sophia Loren

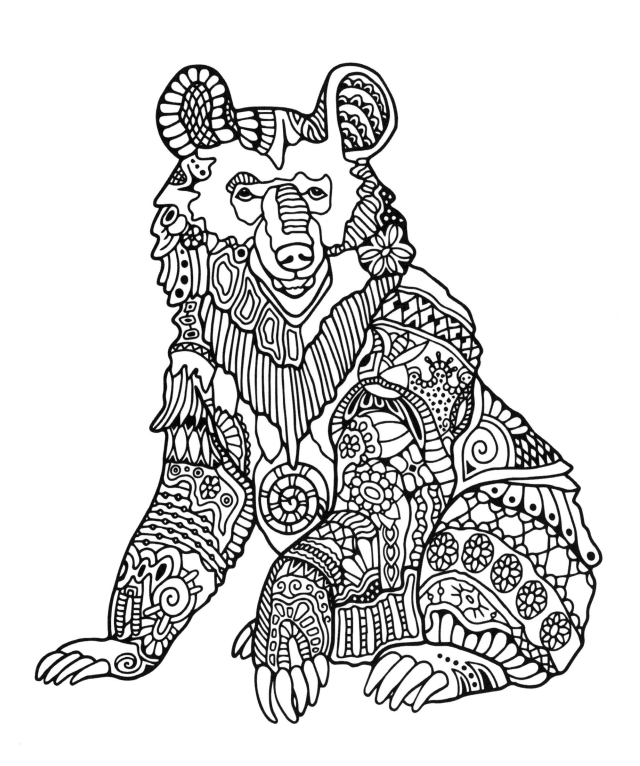

You don't really understand human nature unless you know why a child on a merry-go-round will wave at his parents every time around — and why his parents will always wave back.

William D. Tammeus

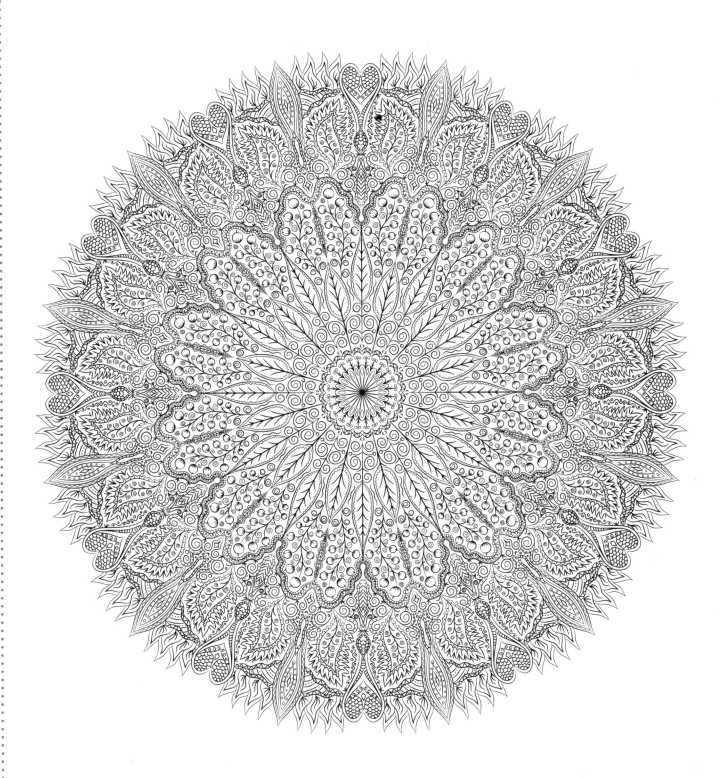

Youth fades; love droops; the leaves of friendship fall; A mother's secret hope outlives them all.

Oliver Wendell Holmes

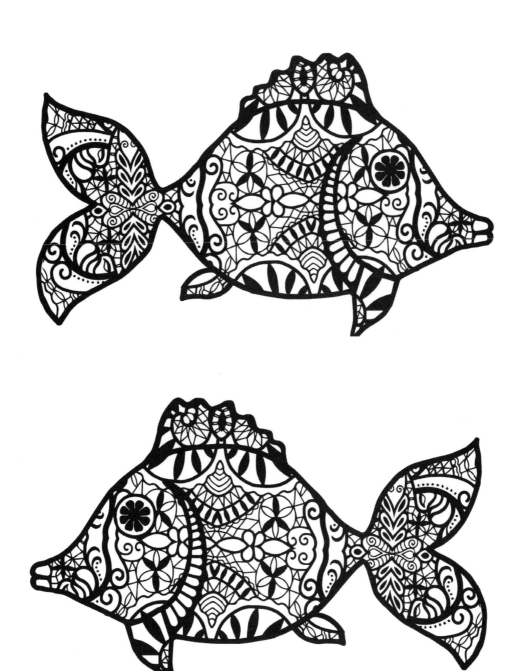

Also created by Chrstina Rose

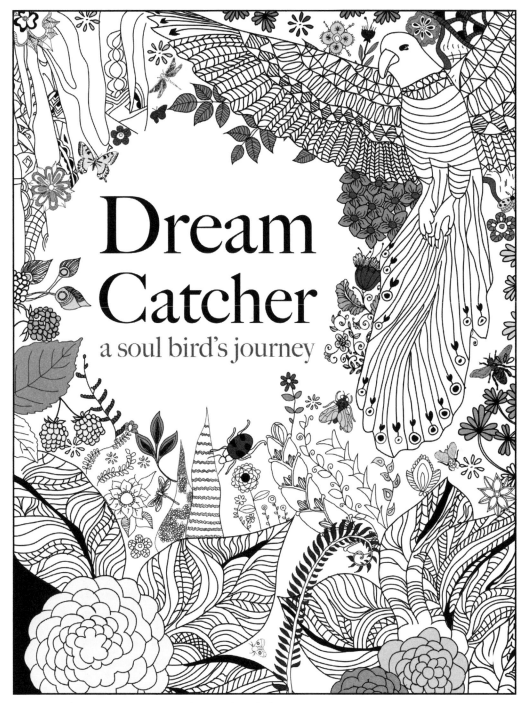

Dream Catcher
a soul bird's journey

A beautiful and inspiring coloring book for all ages

Take a journey of discovery with the soul bird as it travels through a black and white world of intricate scenes and dreams.

Appealing to all ages this gorgeous & inspiring coloring book reaches deeper and further than ever before. Beautifully detailed illustrations and motivational words encourage us to listen to the voice within ourselves and take your coloring journey into a new and thoughtful dimension.